C000154012

'WHY NOT?'
IS THE NEW
'NO WAY!'

# TABLE OF CONTENTS

# TOBIAS KRASENBERG
a.k.a.
# SOPAOOO

Preface
'WHY NOT?' is the new 'NO WAY!'

On the verge of graduating from the Graphic Design Department of the Gerrit Rietveld Academy, I was looking towards the future, the field I might end up in, and where I came from, just to see were I am at right now and were I would like to go.

I found that my outlook on certain things needed a make over, simply because the world and my position in it had changed.

I noticed a lot of people (artists/designers) that I was interested in or respected and who've always had affiliation with 'street culture', 'youth culture' or 'counter culture', were working with big corporations. Being sponsored by them, developing and co-branding products together, etc. It was not just the people and their work, it was also all sorts of events, exhibitions, parties competitions, publications, etc. that had corporate involvement. Some with giant logo's everywhere, others were it was almost kept a secret.

Naturally I've seen these things before, but the attitude towards it was always "Of course this is awful!", 'cause youth culture to me meant 'do it yourself', 'underground' and 'against'. We weren't gonna fall for their seduction techniques and if you sold your soul to the devil, you were finished in my book.
A sort of 'what ours is ours' mentality.

In lack of a better word, I was somewhat 'surprised' that, the critical attitude I always valued in certain subcultures, was nowhere to be found.

For a long time young creative subcultures were reluctant (to say the least) to work with big capitalistic entities or to their involvement in any other way.
There was a reason for this, or a few actually.
Involvement of corporations would often mean you would have to compromise your independency, your goals, your politics, your (artistic) integrity, your culture and eventually yourself.
To keep these things clear and pure, big money business was kept far away from it. You were supposed to be 'in it for the love', not for the dough. Anyone making good money for his own pocket, selling the culture, was considered a 'Sell-Out'. It was not making money per se that was frowned upon. It was the fact that usually the image that was sold was not true to the culture. It had to be made bite-sized and sugarcoated to be able to sell... and that was a big part of what made it wack. Ad agencies and companies also often straight up stole or copied visuals, music, fashion and everything else they needed to sell something, without any respect to the original artist or culture.

I was interested especially in young creative people who come from a certain youth subculture, like graffiti, skateboarding, music, etc. because when you're part of a subculture you might have more responsibilities. It's not just yourself who you speak for or give image to. You also have to think about the effect your work has on your scene.
I wanted to find out how other young creative people construct their moral boundaries and opinions in the middle of all this.

## - WORKING ISN'T CAPITALISM

Street culture was about doing it yourself and doing it right, and the kids on the street would support you. In skateboarding for example they 'did it yourself' so well that all the small independent companies surrounding the scene got almost as big as the mainstream companies, or they got bought by them. So the kids have nothing small and alternative to support anymore, and the industry of billions has turned the riders into skating billboards.
But it also made for younger, 'cooler', better companies that invest and give back to the culture they came from and still have a bit more respect than the big, mainstream corporations.

My frame of reference needed a renovation, whether this was because I'm changing from voyeur to participant, from fan to producer, or because things around me were not the same shades of gray anymore, doesn't matter.

As a working title I decided to change the left wing slogan "Capitalism isn't Working" around to "Working isn't Capitalism", to open up my out-dated judgments and to start looking at the situation with a different eye.

I started to see collaborations and deals that actually appeared not so bad, and I saw things happening in which corporate involvement didn't just have negative effects but also positive ones. Companies were offering great amounts of 'freedom' in the design process, for

example, by letting artists and designers do what they do best; 'their own thing'. But still the feeling always remained that something wasn't just right.

Like the principle underneath it all was: "A happy slave won't try to break out. And if you do decide to break out.... wait! Here's a free pair of shoes!"

This was a situation that consisted of so many separate and different situations. I saw it happening all around me, and I would probably come to deal with it from a, to me, new position... So I decided to investigate and research this phenomenon.

I decided to just ask the things I wanted to know to people that I respected and that have had some experience with the matter.

## - HOLDING HANDS ISN'T LOVE

When my vision would get somewhat clouded, while working on this project, I looked at the relationship between creative youth culture and commerce as a 'human to human' relationship. You could say that for many years culture was involved otherwise and the manipulative way Mr. Commerce was trying to get Ms. Culture into bed made the whole thing turn sour and they seemed destined to live separate lives.

Still attracted to each other, an occasional one-night-stand happened nonetheless. Often resulting in nothing but trouble...

Then all of a sudden, tired of the power play and both at a much more mature level, they see the potential strength of a real long-term relationship...

Best Company, a marketing innovation agency I've interviewed, state that commerce and culture are in bed together and they're making babies...
I say: "We might be holding hands, but we're not married yet!"

## SELF-MADE SELL OUT

The change of mentality amongst the youth of today is probably the most extremely visible and maybe partly influenced by American Hip Hop, which is now all about 'paper chasing' and 'getting yours'.
It's a new kind of capitalism and almost a weird kind of anti- idealism.

You can see a lot of people coming from 'street' culture using the same outlook on business as on what they used to do with BMX-ing, or graffiti.
They see opportunities to 'put that tag up' or 'do that trick'. It doesn't matter if you skate on the steps of a bank or paint on somebody's door. To them, it's about the fact that you do it and the style you do it in.

Let's say it's good that companies are looking for a more profound relationship by showing more responsibility and offering better deals, but let us always remember that no matter how much 'humanity' a company can show, in the end its just a legal entity out to make bucks.
And if this is something we know, we can no longer blame only them for what happens, but also take some responsibility ourselves.

Is the relationship between commerce and creative youth culture really improving or is it merely another marketing trick?

As Erosie will tell you in the end of this little book: "You decide!"

# MIKE CLARK
a.k.a.
# JEROEN S.

Working in PR for, amongst others, Nike.
(Street-)artist. Free lance graphic designer.
Organiser of (cultural) events. Writer for
magazines. Skateboarder. Student Culture and
Management.
www.iwillnotdrawasiamtold.com

- You do a lot of different things under different names, what is the reason for that?

The foremost reason for me having two names is a practical one. I don't want people, that know my work from the streets, to know me personal right away as well. There's no need for it, the work speaks for itself, I like having this anonymous identity, and of course, it's not exactly legal what I'm doing.

- Do you treat Mike Clark and Jeroen S. as two different identities?

Yes and no, I don't treat them differently because of my character. It's not that the two differ in how I am. However, when I was asked to write a weekly column for spunk.nl, I chose to write it under my own name, Jeroen S, for the reason that I didn't want people to think that I was prejudiced to artists that I was writing about. The column was about letting people know more about 'street art' and it doesn't matter where it comes from if you can see that the author knows enough about it.

Basically all the painting that I do is under the name Mike Clark, except for work that I'm doing in the city I grew up in. A lot of people know me there, also in the city council, as I had two internships here. They know me personally but also by my art under the name Jeroen S. I don't want them to know me as Mike Clark, being responsible for stuff in the streets.

Actually, I have been working on a new project, together with Hetzer, about Multiple Personality Disorder. The project contained research on MPS and resulted in a video installation shown at a gallery in Amsterdam. The project was dealing with my different personalities, during the research I actually gained to new ones. Mijndert, a 'corpsbal' who plays all the women, and Vinnie Leuk, an Amsterdam based D.J. The video installation showed all our different personalities to the viewer.

- Are there things that Jeroen would do that Mike wouldn't, can you give some examples?

At this moment there isn't much Jeroen would do that Mike wouldn't. It's not really something I think about as well. I don't get offers for things that Mike would not do which I then would pass on to Jeroen. Because of this I'm also building two separate portfolios, but if I do something I'm doing it for the love of it, or the fact that I believe in it. To me it would also be kinda hypocritical to have too many differences between these two names.
If I would come across a job that I didn't want to do or link my artist name to, I would try to convince the client with a more interesting idea. I see it as part of my responsibility to make things interesting, for me and for the public.

- You're a fanatic skateboarder, fanatic street artist and you wear almost strictly Nike. There has been lots of discussion about the

involvement of big brands/corporations like Nike in those cultures.

Where street art is considered a critical response to the commercial over- presence in public space, skateboarding has turned into basically advertising on wheels.
Nike being a good example of a brand that had a controversial but very successful strategy of conquering the scene.
Where do you stand in all this?

First things first. The reason that I almost only wear Nike is because my mother has been working at Nike for a long time. Through sample-sales and discount sales I get a lot of stuff for free or dirt cheap.
That's the main reason I wear Nike. If my mother would have worked at Adidas, it would have been the same. The sweaters that I have and wear the most are sweaters from my ex-girlfriends. I dislike buying new clothes, and especially paying way too much money for it.
It's the nature of things that something starts out slow and gains credibility under a group of mostly young people, who then start to spread the word.
With corporations wanting to be cool and hip, it's only a matter of time before they notice this scene and/or movement and start reacting to it. Which isn't always a bad thing. As long as it happens in an honest and transparent way, the scene and/or movement can use this to move forward as well.

I've accepted the involvement of commerce in almost every aspect of life and I see it as inevitable. What's important now is that we make sure we get something in return.

Within almost every scene, it's about developing your skills and lifting yourself to a new level. I think that without the money of big corporations like Nike, that process takes longer or might not happen at all. Skateboarding did perhaps become advertising on wheels but you should realize that the main coverage comes from the X-games or some sponsored event where you only see advertisements and you start to wonder if the skateboarder wants to be there himself or that he just got caught up in some sort of contract clause and had to be there for his sponsor.

Besides the X-games there is much more going on, there is always a scene that revolts against this, and these scenes are perhaps more interesting again because the 'developing' and 'lifting yourself to new levels' is happening here, with the money and possibilities the big corporations are providing. For example, Danny Way is a skater who skates for DC, a skate-clothing and shoe company. With the money of DC he built a ramp so big that he was able to jump over the Chinese wall. Something that would never have been possible without big corporation money.

- Where is your personal boundary in doing commercial jobs?

My personal boundary at the moment lies in whatever I want to do. If I want to do it, I will. However I will not use my own art for display purposes in stores or whatever. My art should remain 'my' art.
I would rather make something new, especially for that store. And the shop would have to pay me for that, of course.

My personal boundary is also depending on the state I'm in at that moment. If I would get an assignment for a big piece, nothing refreshing, nothing special at all, but which doesn't go against my beliefs either and I would need money at the moment, I'm doing it, as where if I wouldn't need money I might not do it. We don't always have the luxury of having principles, but we almost always have the possibility to twist things in a way that we can still have a good time and put the situation to our hands.

As for brands, whenever a brand feels me, and I feel the brand, and we both see where we are going, I see no problem in collaborating. It depends so much on the situation(!), but basically it's about mutual respect.
Personally I see it as an acknowledgement if a big brand wants to relate itself to my work and I'll make sure I'll give it the props that it deserves.

But we do have to consider that there is a difference between my art and the illustrations and designs that I make. The last two ones are nearly only for assignments. My art is another thing. I wouldn't let

a brand use "I will not draw as I am told" for their campaign. Because "I will not draw as I am told" is a very personal statement to me, it wouldn't make any sense to 'sell' this statement to a company.
The statement is about me, not about the company. That is a boundary for me, using my personal statements for a commercial client that pays me to do a job. What's mine is mine.

- Can you give some examples of successful or cool collaborations/sponsorships and examples of the opposite?

I think the Blend magazine and store is a good example, with their Blend Guerilla stores they opened stores in 4 cities for 60 days. Within these 60 days the Blend store was a good example of how they gave space to artists to do their own thing. In the city of Arnhem, I was able to expose my art and paint some walls as well.
It gives young creatives a lot of exposure, also in the press and other media.
One of the worst examples I can think of at this moment is Desperado's. A Mexican beer brand. They launched a huge stencil/sticker campaign in big cities and hit Rotterdam really bad. They literally went over the entire city with stickers and stuck everything they could find. In the process they even sticked over other stickers and pissed of a huge load of people. This is a good example of a brand that wishes to identify with the 'cool young kids' but only uses them for themselves and show no respect to the scene that they want

respect from. Something like that is 'not done' if you would ask me. The scene will notice it if you only abuse them for making more money. If you really want to identify with the young hip and trendy you have to give them the opportunity to grow as a scene as well. And therefore you have to have something to offer them. And not steal from them. The kids are smart enough to see what companies are trying to do in cases like this and if you're a young creative and you are helping companies to do this, you will also lose the respect of the other kids!

- Can you paint me a picture of the ideal relationship between commerce and creative youth-culture?

In my eyes the perfect relationship between commerce and youth-culture is a relationship where both have got something to offer to each other. As a brand, you can't 'invade' youth-culture and use it to profile your own brand, and not give something in return. The scene will find out, and will abandon you and your brand. And the scene itself will eventually dry out, because there is nothing exciting happening anymore.
When a brand gives something back to a youth-culture it gets even richer, not only in money but also in opportunities, creativity and motivation.
The scene gets lifted and that can only be a good thing.

A lot of contacts made between commerce and creative youths, hold opportunity for the future too.

- Working in PR and being part of the young creative world, what would you say the dangers are for young creatives working with big clients?

You should only do something that you want to do. Stay close to who you are. Try and find clients that feel you, and the direction you want to go in. Brands are always very secure about their image, so you have to be secure about yours and at the same time you should make them feel comfortable that whatever you want to do fits that image. Be aware that the client doesn't just use you for that "cool hip font" they want in their ad, but make them think about giving something back to the scene. And remember: the bigger the client, the bigger the money. Don't let yourself get off with something like "your design is going to be on our stuff, think how many people are going to see it!". Sure, people are going to see it, but think about how many people will call Nike, or whatever company, and ask who made it!

And don't forget, keep doing your own thing, and keep working on yourself and your own art.

# KARL GRANDIN

a.k.a.

# MONEY-KALLE-WINSKI

Graphic designer. Illustrator. Part owner of clothing-brand Cheap Monday. Graffiti bomber. D.J.

www.vaar.se

- As a designer you've worked with commercial clients at a very young age. What can you tell us about that experience?
You recently graduated at the Sandberg, what does your professional life look like right now and how would you like it to look in the future? The good, the bad and the ugly, please.

First of all, what is a commercial client to you? Even museums and art institutes (I presume these are clients you would dub 'uncommercial') are part of a commercial system, or a system of commerce, whether we want it or not. But when I think of the definition 'commercial clients', I think of advertising and campaigns and that has never really been any interest of mine.
I was mainly into magazine design and typography when I first started working. I started out designing a non-profit magazine about children's books and about a year later, I became employed at Dynamo, a small design studio in Stockholm. We did the art direction for Pop, Sweden's only independent music magazine at the time. This led to a number of other projects – we developed the small book publishing firm Koala Press, a film fanzine called Filmpremiär, we released a number of independent records and we organized an annual music festival. But we were also designing logos, websites, annuals for a number of companies and stuff like that. I enjoyed this balance between working with projects that actually brought in some money and then spending them on projects that we had a deeper interest in ourselves.

However, after some years the company started to expand, growing from three people when I joined, to about ten, and it felt more and more like working in an ad agency. So I decided to do something else.

Since then I have been working freelance, mainly together with Bjorn Atldax using the common signature 'Vår'. Today we spend a lot of time working with a group of fashion/clothing brands. Among them are Sunday Sun and Cheap Monday, two brands that I started a few years ago together with a few friends. But I am also working on my autonomous projects, some of which I instigated during my time at the Sandberg Institute, and do freelance work for clients like Amnesty International as well as local galleries and undergound record labels. I'd say a good mix of working for myself, for my own peoples and for clients.

To really simplify things you could say that big clients have more money to spend and so-called cultural clients have less. The problem with more commercial clients is that the project will always be an investment to them. Today, I avoid working with projects where the result is measured in profit. My experience is that people define the term 'commercial' in a variety of ways. The Netherlands, Sweden, the US and Japan have very different ideas about it.

- Looking back, do you feel like you had enough time or life experience to formulate your ideas and ideals about being a graphic designer?

Yes and no. A huge difference between graphic design in Sweden and Holland is that up here (Sweden) the schools are generally more practical and less theoretical, graphic design is traditionally considered a 'craft' rather than an 'art'. This means that not a lot of government money — grants, etc — is spent on graphic designers and the designers have to find a way of making their own money. The greatest thing about art/design school and environments like that is that you have the opportunity to talk about your ideas, experiment and that it is ok to fail. It might not feel ok, but it is. I think formulating ideas and ideals is something that never stops.

 - At a later age you decided that you wanted to do more work in the cultural field and you started a study at the Sandberg Institute. What triggered that decision?

The reason I came to the Sandberg was that I felt that I needed some change in my working situation. I was developing a number of projects but felt that I did not have enough time to concentrate on the parts of the work that I really enjoyed. It was not really a matter of commercial vs. non-commerial work, I just had too many things going on at once.
Studying at the Sandberg gave me a sort of break, the opportunity to focus on my autonomous projects and figure out what I wanted to do next. It is important to me to change my way of working and living every now and then — try out new types of projects and

media and work with new people and move to new places, parts of the world that I have not experienced. I think The Netherlands is a great environment for a graphic designer today but I also think it is very important not to get stuck in one place or a single mind-frame.

- The relationship between young (underground) culture and commerce has been changing. More and more collaborations and sponsorships are occurring. What used to be considered "selling out" is now considered a status symbol.
What is your opinion/view on this situation in general and how do you construct your personal boundaries?

I wouldn't say 'selling out' is considered a status symbol. It's still wack. But 'selling out' is yet another term that is constantly changing with the times.
I am very picky when deciding on what clients to work with, but that is mainly because I am spending most of my time working on projects of my own.

- Exactly. It is a term that changes meaning over time. There is a change happening right now. I guess what I mean by selling out in this case is making money off a culture that claims not to be about making money.
You were expected to be in it for the love, making cash with that culture was quick

considered to be proof of not "keeping it real" .
What do you consider to be "selling out"?

Have you ever been in the situation that you
were questioning yourself if you would be selling
out (to your own definition) if you would do
a certain job?

Every single time a client asks me to do something
for them 'in my style' I need to consider whether that
is good or not. You need to have some love for the
projects you do in order to make them turn out really
interesting. All artists, graphic designers, illustrators,
etc. are at times forced to work on projects or for
companies that they are not completely into. And most
of these projects will not turn out amazing but I do not
think that makes you a sell-out.

I think it is great if you can make a living doing
something you like, working with a culture you are
down with, but do not let a boring client trick you into
turning that culture into something less interesting.

I have a sense of what I want to do and where I want
to go. I have to admit I have not planned much during
my career so far but I believe it is important to have at
least an idea about what you're aiming for, what your
next step could be, in order to form an idea of what
you are about and what your skills could be used for.
If not, you are easily victimized, you become the very
project you are working on at the moment.

- What would be your advice for young graphic designers when dealing with big clients?

Advice has a tendency to sound corny, but ok... here we go!

Think about what you would like to do, what you would like to get out of the collaboration.
You have to make sure they don't chew on you and spit you out something you're not. And make sure the Big Client pays, even though they try to get you for free by telling you that 'it is a great way to get your work out there!'.

By doing things your own way you will actually change the world.

# GEWOON MARCO STERK

Graphic Designer. Musician. Part owner of
creative company 'News'. Skateboarder.
Owner of independent record label 'Special Box'.
www.newsnewsnewsnews.net

- You have been active in the design field since a very young age, can you shortly explain how you came where you are now?

I started out doing websites during the end of the dotcom era, after that I got more interested in graphic design. Mostly because websites are never finished, and I find it hard to make final decisions.

In 2003, I started News with Orpheu de Jong, Meeus van Dis and Jonathan Puckey. At first it wasn't really a business, we just wanted to do all sorts of stuff together. We wanted to work in every medium possible. We did a lot of visuals for clubs. After a while Meeus and Jonathan left, and we tried to make a living out of it, and we've been doing that ever since.
We still do all kinds of stuff, cultural and commercial.

- Have you noticed a change or shift in the relationship between commerce and culture (especially youth culture) over the past few years? It seems that big corperations figured out a way to deal with young creatives and their culture. What's your view on this change and where do you stand in the current situation?

I don't think big companies figured out how to work with young creatives. There's a lot more young people working at bigger companies now, that automatically involve young creatives. I think it's great that we can work more with brands that will let you do your thing.

Most people we work with, at a big company like Nike, or bigger ad agencies don't wear 'the suits' anymore. Interestingly enough all the suits are worn by the cultural foundations and museums.

'The Man' now works in the museum (at the Stedelijk Museum to be precise). In my experience there is not necessarily more freedom in cultural work, they just pay less and demand more. Commercial work does have more guidelines, but that's what makes it more interesting for me, from a design point of view.

- How do you decide if you want to do a job or not, have you ever turned down jobs because of principle reasons?
How do you formulate your boundaries?

I can't recall that we have ever turned down a commercial job. We have turned down cultural jobs, however, usually because they want us to work for free. Which is fine, if you ask nicely... But in a lot of cases they just expect you to work for free. Like it's them doing us a favour! You could say cultural and commercial initiatives have switched attitude and tactics towards young designers here.

- When working with cultural or commercial clients, what are some of the differences you experience? Do you approach them differently?

We approach them the same to begin with, but the

outcome is usually different. In commercial jobs there are more guidelines to start with, but within those guidelines you can do whatever you want, you just need to be able to sell it.

There's a lot more clarity there, you have a strict budget and a clear briefing. However sometimes you have to pitch for free, which could result in nothing. In cultural work, sometimes you can do what you want, and it works out great, but sometimes the client will tell you to 'just do your thing' (which is a bad sign) and at the final presentation you get a big list of changes, or just straight up tell you they don't like it.

- If we conclude that the relationship between young creatives and big clients are improving, where do you think this leads us? What will be the effects on youth-culture for example...
Lets put it like this: The Best Company state on their website that high and low culture are in bed together and they're making babies. What do you think these babies will grow up to be like? Being part father of these babies, how would you like to raise them?

I see a lot of good things happening, if the companies are younger it will never hurt youth culture.
And I see a lot more opportunities, as there will be more resources. I regard it more as a Fetus in Fetu, you know, when you have your mutant twin stuck in your stomach, but it's still growing. You can't deny it! I'd raise it to be a mutant typographer superhero.

- Can you leave us on a critical note? Do you have some advice/ warnings/ wise words for young designers working with big clients?

There is no 'Them', only 'Us'.

- Open mic. Anything to add?

Don't trust anyone over 30!

# INLUENZA

a.k.a.

# JEROEN JONGELEEN

Independent Artist. Vandal.
www.flu01.com

- English Translation can be found on page 42.

Ik begrijp je vraag. Het is een gebruikelijk onderwerp dat regelmatig de kop opsteekt en waartegen niet veel jonge mensen een kritische positie in kunnen of willen nemen. Cool, glossy, funny, vet en wreed zijn is gemakkelijk te verkopen zonder een gevoel er iets voor in te hoeven leveren als er ook daadwerkelijk niets achter schuil gaat.
Een serieus probleem op de toegepaste afdelingen van kunst academies en in de carrieres daarna.

Ik ben geen creatieveling  -wat een veel te vrijblijvende relatie suggereert met wat we doen en maken- maar een beeldend kunstenaar die onze relatie in de samenleving met 'het vrije woord' als z'n beroep probeert te maken. Om de positie van dit zgn vrije woord duidelijk te stellen gebruik in vormen van vandalisme om dit in verschillende situaties te illustreren en te bespelen en onder druk te stellen.
Dingen doen die met momenten nèt wel of nèt niet kunnen, afhankelijk van de context.

Dit is een polair systeem met, inderdaad, allerlei good guys en bad guys, of in ieder geval ideale posities waarbij de lading van een standpunt van een kunstwerk of gedachte, ongestoord de weg naar zijn publiek vindt, of een die dat niet doet of totaal vertroebeld door allerlei ongewenste invloeden van buitenaf.

Ik heb het hier dus niet over een nietszeggend

getekend (maar vast heeel mooi gedaan) poppetje op een wit gelatexte muur, maar over een politieke positie die de kunst(vormen) gebruikt om zich verstaanbaar te maken voor een breder publiek.

Ik ben niet (en ook nooit geweest) vies van geld, maar wel van het aanvreten van mijn relatieve onafhankelijkheid als 'vrijspreker' (om het beestje in ideaal maar een naam te geven).

Ik wordt nog steeds intens ziek van het stiekem infiltreren van bedrijven in de boodschap van kunstenaars. Het parasitair gedrag wat alleen (financieel) goed is voor de maker van een werk, maar desastreus voor de boodschap van het werk zelf.

Een beeldend onderzoek dient onafhankelijk te zijn of in ieder geval zo onafhankelijk als relatief mogelijk is. In de pyramide van de krachtenvelden rond een kunstwerk, dient het werk zelf en de vragen die het stelt bovenaan te staan en daaronder alle andere elementen: media en aandacht, geldstromen, podium, context, etc.

Het ernstig probleem met sponsoring is dat de intentie van de sponsor altijd boven het werk blijft hangen. Een beschilderde Nike schoen blijft een Nike schoen, en zal ook nooit als iets anders gezien kunnen worden dan een poging van Nike om zich in een cultuur te zetten. Voor Red Bull idem, of Absolut, Heineken, of al die andere pseudo-genereuze bedrijven die verder eigenlijk geen fuck met de cultuur waar ze zich

proberen in te werken te maken hebben, maar uiteindelijk alleen op platte omzetverhoging uit zijn.

Die hele sponsoring-praat hangt daarentegen natuurlijk alleen aan die hele streetart-taal van het vrolijke poppetje (The London Police en cornuiten). Hartstikke fun en happy, maar ook lekker gemakkelijk want, hol als een kindersurprise-ei.

Het is gemakkelijk en eigenlijk maakt het geen fuck uit of daar nu wel of geen Carhartt-logo opgestanst staat.

Wat het is, is dat als er eenmaal een associatie is met een manipulerend merk, het bijna onmogelijk lijkt om het werk en de oorspronkelijke bedoeling weer vrij te maken van de 'corporate stench' en naar een meer onhafhankelijk niveau terug te brengen.

Het is het werk en waar het voor staat dat het geschenk is voor het publiek en niet de steeds toenemende invloed van de sponsor die zijn betuttelende 'vrijgevigheid' wil tonen aan het publiek van de kunstenaar.

grt,
Jeroen Jongeleen/ Influenza

# INFLUENZA

### a.k.a.
# JEROEN JONGELEEN

Independent Artist. Vandal.
www.flu01.com

I understand your question; it is one of the usual subjects that comes forward regularly and one against which not many young people can or want to take a critical standpoint. Cool, glossy, funny, phat, dope can be sold easily without any feeling of sacrifice, if in fact there is very little or no substance behind it. It is a serious problem at the applied departments of art academies and in the careers that follow thereafter.

I am not a 'creative' –which in my opinion suggests a much too engageless relationship with what we do and make– but an artist that is making an effort to make our relationship with 'the free word' in society, into his main focus. With the purpose of setting this so-called free word into the right position and perspective, the use of vandalism is applied to illustrate the real meaning in different situations, play with it and put the pressure on. To do things that, at certain moments, are just barely or slightly unacceptable, depending on the context.

This is a bi-polar system with, indeed, all kinds of good guys and bad guys, or in any case, ideal positions from where the intention of a standpoint behind a piece of art or thought can unimpededly find its way to the public. Or evenly possible, from where it just does not do that or it will be completely troubled by all kinds of undesired influences from outside.

It want to make clear that I am not talking about an insignificantly (but I am sure, very, very beautifully) drawn little figure on a white latex wall, but rather

about a political position that is using the (forms of) art in order to appeal to a wider audience.

Furthermore, I am not, and never have been, against money, but I do vehemently object to anyone or anything that tries or aims to erode my relative independence as 'user of free speech'.

One thing that still gives me a feeling of intense sickness is the sneaky infiltration of commercial corporations into the message of artists. It is a form of parasitic behaviour, which only benefits the maker of the work (financially) but has a disastrous effect on the message of the piece of art itself and the ideals it tries to communicate.

Visual research needs or should be independent, or in any case as independent as is relatively possible. In the pyramid of forces around a work of art, the highest priority should be given to the piece itself, its topics and the questions that it leads to; all other elements like media and attention, money flows, stage, context and others, should come on lower ranks.

The most serious problem with sponsoring is that in most cases, the intention of the sponsor is almost always dominating the message and mentality of the art. A painted Nike shoe will always remain a Nike shoe and can never be seen as anything else than an effort from Nike to position itself into the world of culture. The same goes for Red Bull, Absolut, Heineken and all those other pseudo-generous

enterprises that really do not give a shit about the culture that they try to impose on, other than promoting the ultimate result of the usual increase of their sales.

All the conversation around sponsoring is obviously related to the conversation of the whole street art-language of the happy little figure (London Police and the like). Immensely funny and happy of course, but also a too simple way out because it is as hollow as the internationally famous chocolate 'kinder-surprise-egg'.

It is easy-does-it and it is of no importance whether or not it shows a Carhartt logo.

The thing is, once associated with a manipulating brand or two, it seems almost impossible to liberate the work and original intention from that corporate stench again to more independent levels.

It's the art and what it stands for that is the gift to an audience, and not the ever-expanding power of the sponsor that wants to show his paternalising generosity to the artists' audience.

Cheers,
Jeroen Jongeleen/ Influenza

# BEST COMPANY

www.bestcompanyamsterdam.com

- First of all, how would you describe what Best Company does?

We are a marketing innovation agency developing projects in various cultural contexts (music, [street] art, fashion, publishing,...) for brands, by working directly with the creators of these cultural contexts.

- "Commerce in fact needed culture to innovate, explore new grounds together. And culture learned a marketing trick or two in the process. It was simply the way the post-modern world was turning."

This is a quote taken from your website. You were quite insightful at the time, I'm sure there were a lot of noises against this evolvement and there must have been a lot of discussion. What were some of the arguments you've heard and what was your reply? Pro's and con's.

Best Company strongly believes that brands are part of culture and in that sense have some kind of responsibility. We think it's a brand's duty to support certain contexts or scenes (fitting the brand's values). What is crucial, if you want to generate long-term effect, is integrity and respect. The brand should never mingle with content and programming for example. In that sense we strongly oppose to what's called 'experience marketing' where the brand values come literally alive in a program custom made for the brand,

like a 3D commercial. This is totally top-down instead of integrated.

Let's make it more concrete.
There's a big difference between Red Bull asking some street artist to make a piece supporting their bull icon or creating a platform where artists can make or show autonomous work. Red Bull's brand values can be expressed by a challenge or call for the artists.

Also, in the last decade, brands became better and better at niche marketing, taking up more and more 'autonomous' spaces. So it's almost unavoidable for culture not to participate. It's the ultimate post-modern stance.

- What do you think is the main interest for big brands to work with young and relatively unknown designers/ artists?

Get fresh and original, almost 'virgin' work.
The younger generations, being children of this post-modern stance, are very much open for this kind of collaboration. They're more eager to market themselves as well. They see a win-win situation.

- Another quote from your website (on the financial crash of 9-11):

"Tough decisions were made, with heroic resolution; we had to kill our baby. There was no

time to feel sorry. After all, that's what bubbles do, they blow up in your face."

Are you calling your previous company "Fanclub" a bubble? Isn't a bubble something pretty but empty? A bubble is also used to indicate something unreal or illusional.
Why did you choose to phrase it like this?

With the bubble we referred to the economic high preceding 9-11, not to Fanclub. The end of the 90's were an era of abundance where brands were very open for experiments.
It was almost as if there was no future. It was all now, I think that's pretty bubblish. Almost blind for what had to come.... I think we learned a lot from that though. We're much more realistic right now. But I also think that the freedom we had back then is very hard to top. Everything seems so much more restricted right now.

- You are well in touch with what is happening in the streets and youth culture, you bring these people in contact with big opportunities but you also introduce kids with the latest and the greatest from the commercial market.
How much influence do you have on the young folks? Can you make anything cool?

It's very hard to say. I don't think we personally make anything cool, it's more a collaboration between us, people we work with, goodwill and trust from our

client. All these things combined sometimes result in cool things, like the Code Red electro evenings for Smirnoff and the Lowlands Dommelsch Infocup.

- Have you ever decided not to work with big commercial clients or people from the creative field 'cause you felt that they didn't share your vision? Which of the two need more persuasion?

Of course, this happens quite a lot. I think it happens on both sides equally.
Lots of creative people still think in advertising terms, which I personally find even more annoying than clients being non-comprehensive.

- Your position is often between the creative and the commercial world. Do you see it as your responsibility to guard and respect both their interests and boundaries and how far does this responsibility go?

We try to create a win-win situation on both sides, respecting both sides' interests and boundaries.
It's funny, because often when we step out of the project and the client deals with the creative party directly, often things go terribly wrong. We function as a translator or moderator in many ways.

- Do you feel young creatives are aware of their personal boundaries (morally or otherwise) and are they strong enough to give them a voice

when dealing with clients? (Do you think they might be a little bit too eager and overwhelmed to guard their boundaries?)

This really depends on the person. I think the younger generation is less strict in working for big brands, as long as they can create something cool.
The 30+ generation seemed more critical in that sense. But maybe also more hypocritical. They would really make a distinction between 'free' work and work made for clients, which they would often be ashamed of.
I think the new generation is much more proud about their commercial work, probably because mutual borders are much more respected.
Brands have learned something in the past decade as well, I suppose.

Marketing in general has become much more creative and the younger generations are much more marketing savvy.

- Let's talk future...
If we conclude that the relationship between young creatives and big clients are improving, where do you think this leads us? What will be the effects on youth-culture for example?

I sincerely hope that brands will become more and more respectful and supportive. That they will really help and sustain instead of pushing their brand values no matter what the costs are. I really hope they will take up their role and responsibility in that.

I know that there are a lot of voices saying you can't expect that from a brand, well I think it's time for a paradigm shift, more than ever. The 'open source' model for creativity (and consumer input in general) still has to grow into its full potential. Now it is merely a marketing gimmick.

- You state on your website that high- and low-culture are in bed together and they're making babies...

What do you think these babies will grow up to be like? Being partly responsible for the parents to have met, how would you like them to raise their kids? Hopes and fears...

We're not really responsible for the parents to have met. It's really a macro trend, a sign of the times. It's like in politics, the world is becoming less black and white. Left and right are being redefined, the same goes for high and low culture, autonomous art and applied art, box-office and art house...

Everything is becoming more eclectic, entangled, a blur of grey scales so to speak. There's no use clinging to the good old days when everything seemed in place, neatly divided in boxes labeled one or the other, although it is good to know where things originated.
The interesting side effect of today's 'chaos' is that we have to redefine our notions, re-think everything.

It's a time for visionary people, it's a call for intelligence and creativity to meet at eye level, as equals.

- Don't you feel that a scene that was once about non-conformism, is now all about conformism? Just to different standards than the average Joe?

That's just a logical development I guess. Scenes right now, at least to my opinion, are much more about looks and style than sharing the values they once did. Media influence of course played a big role in this, and a seemingly never stopping urge for nostalgia. Wearing a CBGB T-shirt is almost pathetic nowadays. On the other hand, in the light of the former question and answer, it is not so strange.

With the world so much more complicated and values so blurred it is much harder these days to choose sides, especially as a group.

Individualism, which is directly linked to consumerism, also had a devide-and-rule effect, helped by globalism, the internet... there are many factors involved. In fact we don't think conformism is the right word. It's more opportunism. This is not necessarily a bad thing. We do see a renewed critical awareness at rise all around us, but there's a "if you can't beat them, join them" mentality.
It's not just 'anti', it's more 'DIY' (Do It Yourself).

- In our previous talk you claimed that "Underground" is dead. Where is the rebellion in youth culture nowadays, or where should it be to your opinion?

Underground is for sure dead. But the fact that it's much more visible than before doesn't mean that everybody sees it. In that sense, I think, it's all the more exciting. I mean, everything is on the internet, but you still have to be able to find it, connect to it, understand it, etc.

-Will every young artist be a product designer also?

With the affordability and proximity of new production techniques, that might very well be possible. Think of the whole DIY movement, new style. But that doesn't mean that they necessarily have to do this.
I think it's more likely that more and more people get creative and act as producers (or at least co-producers) instead of mere consumers.
This would be a nice development.

- Can you leave us with some wise words?

Paradigm shift. Now!
Just as there are environmental changes we can not turn around, the same is happening with rising commercialism and consumerism. I really hope brands will have a sincere look at what they are doing and

pro-actively involve the next generation of creatives, with mutual respect.

I could put some kind of basis rule:
Brands should do what they are good at: making comfortable shoes, making nice vodka, etc.
Consumers (better: customers, even better creative customers, we don't believe in total 'democrazy' here) should provide content.

We think that in the near future a lot of production processes will change, which will have major consequences for marketing and communication.

# PEPIJN LANEN

a.k.a.

## PEP

a.k.a.

## FABFIVEFABERYAYO

a.k.a.

## P. FABERGE

a.k.a.

## SNIKKEL VAN HENGSTUM

a.k.a.

## GAPPIE EAU D'SNICKEL

a.k.a.

## P. DRONQ

a.k.a.

## PEPPICHULLI

a.k.a.

## BEN AL JAARE NBAAZ

Member of the Rap formation 'De Jeugd Van Tegenwoordig'. Writer for, amongst others, Vice Magazine.
www.dejeugdvantegenwoordig.com

- First, can you give a few examples of deals/ relationships that you or 'De Jeugd Van Tegenwoordig have had with brands or companies?

At the moment we're in talks with Globe for our own shoe, designed by us, based on one of their 'classic' models. Furthermore, at the start of our career Heineken produced a bunch of promotional glasses using their trademark lettering and trademark slogan "biertje?" combined with our trademark slogan at the time "watskeburt?!". The produced glasses said "watskebiertje?". This wasn't however a deal between us and Heineken but rather something that just happened during the promotion.

- In these talks with Globe, in this case, what is important to you and to what extend? Autonomy in the design process, proper payment, the way it's gonna be marketed?

It's important the shoe turns out the way we imagined it. The thing is, I don't want my own shoe so bad that I'll take anything as long as they put my name on it. I think it's cool to have my own shoe but I want it to look the way I want a shoe to look. I don't need a logo-shoe per se. Therefore I don't really care about payment as long as the shoe turns out well.

- Through which channels and in what kinda way  do companies approach you if they want

something from you or give you something?

Usually it just starts with a communication towards one of us or our management, asking if we're interested in doing something. 9 times out of 10 it's completely on a friendly base. We've virtually never been approached with signing contracts or anything like that.

Once a representative from Skye Vodka actually offered us a bottle of vodka while driving in a car behind us. Just out of the blue. Willie Wartaal had to jump out of the car and get  it.
Another time this guy literally stumbled over us, getting drunk in a bar and started mumbling stuff about hooking us up with Duffer Denim.

Or sometimes a representative will contact our management, most of the time though, the things offered by people through the official channels... aren't really something for us.

- If a clothing brand offers you free clothing, what's usually the deal?

Usually for the brands it's a question of visibility.
So, if a company sends you a bunch of free stuff you asked for then it's proper to supply them with some pictures in magazines and such, showing you wearing it. On the other hand, sometimes a company will just send you random stuff you haven't asked for.
I've been known to just give a lot of stuff away.

When in talks about the Globe Shoe the people who do Globe gave us a carte blanche in their warehouse. I actually overdid it a little...

Most of the stuff I took was for friends. I got myself a rediculous pair of gold shoes and a pair of sunglasses. But then I hooked my girlfriend up with pyama pants and a T-shirt, and, since it was his birthday, my best friend with a polo-shirt, a zip hoodie and a snowboarding jacket.

And at that point, we hadn't even done anything for them yet!

- What do you think a brand gets out of giving you free stuff?

Mostly visibility. With us wearing it in pictures, for kids looking at those pictures, the brand is recognized as something that we would wear. Not necessarily just that brand, but still....

- How do you feel about that, and the fact you're being 'used' that way?

I don't really mind all that much. And I don't feel 'used' at all. It's how it works. Plus if they don't think you wear it enough they don't send you any more and that's that. It's up to you. Nobody is going to tell you to give back their merchandise because it isn't visbile enough. It's just really low-key. For them, if one kid buys a sweater because they've seen me wear it, it already justifies giving one away for free.

- How do you decide, what you wanna do?
Did you ever end up in a situation that you
weren't comfortable with?

All of the freebees I've gotten over the last 2 years
were 'no strings attached'. So, for me, none of it was
a hard choice. I've been in initial conversations with
companies that didn't really feel right, but those usually
don't go any further than an initial conversation.

- When does something not feel exactly right,
what are right or wrong conditions?

When we were in talks with LeCoq Sportive we were
very interested in making a shoe, from scratch, and
we were really impressed with the numbers they were
throwing at us. However, these talks were held in the
promo office of LeCoq and litterally each and every
piece of clothing on display there was really ugly.
Also they wanted to sell the finished product exclusively
at a store I wouldn't want to be seen in. That sort of
broke the deal...

- With a graphic designer or artist, I can imagine
things being different. Companies want their
work, and maybe also a link to a certain image
or credibility that they have. But in your case,
they want your face and whole persona. They
want you on your way to the supermarket.
As a 'public figure' you have influence, a certain
marketing value, how did you come aware of

that? And how do you deal with that?

I got aware of this thing when people just started giving us free stuff. Without me even asking. All they would like you to do is wear it once on television. Also, I can just call up a company and ask for something ludicrous. They won't necessarily give it to me, but they won't think it's outrageous that I'm asking. I think becoming aware of that came with the realization of being somewhat of a public figure. Over all I usually don't have to deal with it; people just call out on the street which is kind of weird.

It really is ridiculous. Before, you'd go out and maybe try and steal a bottle of liquor from behind the bar. Now you go out and just ask one of the girls behind the bar for a bottle. Nine times out of ten you'll just get one. Or you steal one anyway and get away with it, just because it's you.

- Have you yourself ever approached a brand or company for sponsorship and what do you look for in a deal?

Well, I'm a huge fan of Bernhard Wilhelm's clothing and have worn quite a lot of his pieces in videos and magazine-shoots. When he was in town a while back I brought him a bunch of our stuff , mostly picturing me in his clothes. We had a little chat and he said something along the lines of "if you ever need anything you can reach me through that and that channel".

Of course I was secretly hoping for him to give me a lot of free stuff but I didn't feel comfortable asking for it, then and there.
Also I've contacted Cheap Monday through Samuel The Good, a friend of mine who's a friend of one of the guys over at CM.

On the other hand, when we were in talks with LeCoq Sportif about maybe doing a small clothing line and some shoes, and we first met with them, they had a whole XL -presentation set-up and were talking marketing and figures before we had even discussed what they wanted from us.

- What would be an ideal situation between you/ De Jeugd Van Tegenwoordig and a brand? Best case scenario, wet dream, fantasize away!

For me personally, I would like to collaborate with someone like Bernhard Wilhelm. Or Raf Simons or the Japanese label Neighborhood. Creating a clothing line from scratch with a unique designer. Just quality stuff. I wouldn't mind signing endorsement contracts for something like that. Being involved in the whole thing, like making the promotion around it as well. Taking pictures, coming up with weird locations and influences that would be…. great!

I like getting stuff for free. But really working on something as a whole, being involved from scratch and being a part of the creative process is what I would

really like to do. It's not a money thing either. I make my money being an entertainer/writer. I think it would just be really interesting to try and see how something like that would work out.

- Before, when you were just a skinny kid with weird hair, did you feel different towards corporate involvement in the music industry than you do now?

Definitely. I was convinced that people got paid to wear certain brands and that that was that. Now I realize brands just send stuff to people. Also, I look at corporate involvement differently.

Something bad to the outsider can be a really good thing business-wise for an artist or group.

- Was that a difficult moral shift? Can you give an example of something that might look bad on the outside but is actually good for the artist?

It's just something logical. When you're suddenly on the inside you know why it's good to appear in a kids show. You realize that it's good for the allover goodwill to sometimes see what people from a certain brand or company have to offer before turning them down. I know people look at Lange Frans and think: he sold out. He didn't sell out; he crossed over.

He knew that all the tough streetkids didn't think he was cool anymore as a rapper, and so now he's an 'entertainer'. I dont know how smart it was to do that GVB commercial but I understand why he would do that. I have to say it's not my thing, but I understand.

- Sponsorships or doing commercial 'schnabbel' jobs is risky business, especially in HipHop.
On one hand it's very accepted and looked upon as an accomplishment. Yet on the other hand, one wrong move (wrong company, wrong ad campaign) can completely kill your reputation and credibility as an artist.
How aware are you of this and how does it influence your decision making?

I only pick things I want, brand like, so if that's something "the scene" doesn't approve of, I don't really give a rat's ass.

- What do you think of product placement in music videos and even in lyrics. In (American) Hip Hop, this is something that is happening to a ridiculous extent. Where do you think your personal boundary is?

I'm not sure. It really depends on what people ask and what it means for me in terms of payment or something like that. It's not something I'm definitely against but it is something you have to be careful with. I would

never promote something I don't believe in. Whether it's a brand of jeans or an insurance company.

- This 'believing' in it, is somewhat unclear to me, everybody says that. I understand you wouldn't advertise something that is obviously awful to mankind in a video. But how much can you believe in a fancy phone or car or whatever? These are products that are very obviously marketed in American and Dutch videos. So what is important in your choice here? Would you only use something in a clip that you would normally use anyway? Is it a good way of getting something that you would like to have or is it a money thing?

That's what I mean when I say believe in it. If it's something I would use anyway, or would want to have, or if it really adds to the concept of a video, for example. I would be careful with corny stuff like insurance or stuff like that, it just doesn't make sense for me to promote that. On the other hand, if a commercial maker came up with a really strong concept for a commercial for something like that, and it would really suit us, I would definitely look into doing it.

- In the beginning of your music career, things blew up really fast. From nothing to a huge nr. 1 hit in all the charts. I can imagine things being very exciting and overwhelming. How long did

it take before the companies showed their interest, and looking back on it now, how happy are you with the corporate involvement? Were you supported, ripped off, bullshitted or respected?

At our debut album release party Heineken just did us a favour. For them it was a good way to show their involvement in youth culture, and, being that Heineken was already my favourite drink. I didn't mind it at all.

It wasn't really a deal with us. Hendsum and Young (a marketing agency who work closely with TopNotch, our recordlabel) have a connection at Heineken and they hooked us up with the release party powered by Heineken. Looking back I would have liked more deals with Heineken, me being a fan and all. But this was way in the beginning before we really realized how much you can get from a company like that.
It just sort of happened and then floated by.

- Please leave us with some advice, warnings, warm words for people from the creative field coming to deal with corporate involvement...

Free is always good! I don't think corporate involvement is a bad thing as long as it's the right company for you. And never sign anything!

# EROSIE

Illustrator. Graphic designer. Artist.
Street art pioneer. Graffiti writer.
www.erosie.net

- Can you shortly introduce yourself, what do you do?

As a graffiti writer I chose the name Erosie since 1998, after doing strictly graffiti since 1993. So it stands for a gradual change I guess, using different fields or media for different purposes, without strictly committing to one way of working only.

- Do you have different rules or visions when it comes to 'free' work or a paid job?

It depends. If somebody pays money, the person wants something in return. If I feel this is not really the case, I guess it's called free work. I try to find a good balance between doing paid work and free work, although best is when the outcome is good no matter what it's for.

- In an interview I read, you said: "If I can, I would like to avoid mixing up 'getting street fame' with 'getting paid'."

Would you do things under your real name that you would never do as Erosie, what are your standards concerning these two entities?

Yes I have done different things with different names for different contexts. It frees my perspective to work in different fields with my own name or as Erosie. Although it doesn't make so much difference to what

I will or will not do. If I think it doesn't fit my standards I don't get into it anyway. Being picky beforehand mostly prevents getting lost in a one-way street. It really depends on the context though, I like using context for trying a different approach, instead of using that same set imagery in everything I do. Doing a kid's book illustration to me is a whole different thing compared to doing a tag or an exhibition. I like this...

- Also you said: "It seems to come down to the fact that having talent is just 50%, and marketing the other 50%. Some people have a bit more of the one, and less of the other. My position in this is double: on one hand I don't feel like thinking like this, on the other hand you want people to see your stuff, to get paid for what you do. It's interesting juggling between 'selling out', doing honourable work, being poor or not caring at all..."

I know you don't like thinking like this, but if you do, what is the equation you came up with for yourself?

Well, I think it all depends on personal intention. My intention is to make good things I consider being important. Things I need to do in order to get rid of an itchy feeling in my head. Earning money with this comes second place, or beyond. So in that case I guess my marketing-side is the less developed part. Being not very easy to pin down to me is a quality, but marketing

technically it seems to be a disadvantage. So be it...
Also, overusing the fact you have a graffiti-related
background seems pointless to me, because this in itself
doesn't really mean anything quality-wise. It still comes
down to what work you do, how you think and what
you make.

I have been surprised all along since 'street art'
became fashionable how easy it seems to get
commercial success with just one repeated image
or one way of working. Compared to great work
being done in the ('not so hip') comics-field for
instance, it's remarkable that street artists get so much
attention. But hey, I'm not such a great comic-drawer,
so I consider myself lucky aswell.

- Can you define 'selling out'? Does it mean the
same for you now as it did when you were
younger?

Younger? As in...? Maybe you mean the difference in
attitude? Keeping it real or selling out may sound very
tempting, but don't mean a thing really. It's all between
the ears. The attitude you have towards certain codes
or people in a certain field amongst others define
this attitude. It can certainly be healthy to update this
attitude once in a while. So selling out is a matter of
personal nuances, although mostly it's said in a very
one-dimensional way.
On the other hand, there are terrible examples of
bluntly selling out. Using graffiti for selling cars or
shoes or hairgel...toothbrushes even (it's true!).

The past years I have seen quite some hilarious examples of that.

- What I mean is, what kind of transition did your outlook go through, when you turned from fan into producer, when you turned what you do into a profession?

5 Or 10 years ago I was much more clear in the separation between doing graffiti and things done for let's say art-school or commercial jobs. I actually blended this more and more over time, since it's interesting to fine-tune my perceptions on different fields but without losing my ideal.

There is something to say for keeping things strict and separated (let's say earning money or doing art separated from doing graffiti for example), but I more and more felt like taking responsibility for doing all the work I do, both commercially and artistically. Maybe this narrowed my commercial options (like I said before due to being very picky, and wanting jobs to fit my standards) but it definitely widened all other options for projects and artistically as well. I guess it's an ongoing adaptation, a never drying clay-sculpture you're trying to shape or something like that...it's exciting. But sure, sometimes there are things you do and feel stupid about afterwards. It's part of the story.

- A quote taken from one of our previous email conversations: "Tis wat Veronica op een

knullige manier doet met blonde tieten en sport-
auto's maar dan anders. Iets 'gesophisticeerder'
zullen we maar zeggen".

It's not exactly the same of course. Veronica is
not freeing up airtime for young artists (yet),
they have horny editors that show horny
viewers what they want to see.

But, nevertheless this is what people do and this
is what is happening, and people like Best
Company say they are trying to move this thing
into a direction that is more based on an more
equal relationship. And if a brand shows a cer-
tain responsibility, or they just realize that it is
also in their own best interest to behave them-
selves in this relationship...and instead of just
taking from a culture they also give something
back?
Like the ART-BEAT event at Museumnacht,
where Red Bull provides a platform for young
(street-) artists to show their autonomous
work. There is no annoying Red Bull branding
anywhere and a possibility is created for young
folks. Then what's against this?
I guess the question is: If the circumstances are
allright, is it still wrong?

I doubt if I agree on your spic and span view on this
'streetwise' branding. It certainly is comparable to the

clumsy bigtitted blondes of Veronica, since Veronica
(a tv-station) uses tits to reach customers (the audience),
or better; they use them to reach advertisers that want
to reach that audience. So it's a tv-station that uses tits
'n asses to get the dough.

An energy-drink company uses 'street artists' to reach
an audience. Or a car-company does the same. That's
quite similar. It's a different way but the same goal.
It can be more camouflaged, but that's still what it is
about. Surely it can be beneficial to some, but
artistically... I doubt if it raises the bar.
It's still marketing. It can never overtake the original
power of doing things in the street. It will never get
more 'real' than playback. It's not like sponsoring in
let's say Formula-1 racing; the money is needed to
simply give it existence. I doubt if graffiti or 'street art'
needs sponsoring to exist. Advertisers need graffiti,
not the other way around.
Graffiti is individual self- promotion done manually.

You talk about 'equal relationship' and 'taking and
giving'; if giving is financially, and people go along
with this, sure they can help. The 'taking' part for
companies is still to upgrade their brand's emotional
appreciation by (young) customers, that generally
don't really see too much difference between the one
artist they use for this purpose or the other.
It's funny. In the book 'the faith of graffiti' from 1974
there is (already) an example of the use of graffiti in
advertising; one difference is that in the ad graffiti is
used as a negative phenomena reflecting an uncivilized

world. Today advertising flirts positively with graffiti.
That's a whole different approach. Is it progress?
I doubt it.

- You seem the perfect candidate for a
collaboration with a brand that's trying to be
'happening'. Yet I haven't seen an Erosie shoe or
anything like that with your name or work on it.
What happened?! Please, elaborate...

Of course you shouldn't ask me this question. Ask the
brands. But also I'm picky 'cause my goal is not to
pimp as much shoes as possible, but to do quality stuff
that fits MY standards of quality. Not the standards of
a brand that just wants someone to fill in their spot.
Mostly I experience brands just desperately wanting
somebody to do it with a similar background. To get
that 'urban' touch. To upgrade their street-credibility.
To get a nice sugar-coating of 'rebellion'. It's probably
better if they ask others for this. If they're genuinely
interested in my work, my personal approach and
ideas towards things, it might be a different story.

Don't get me wrong; I am not against getting paid for
the things I do, or seeing others getting paid.
I am simply more interested in what is made instead
of what brand it's made for.

- Another quote from a previous mail: "Als ik
nog een keer het woord 'rebels' of 'rebellion'
hoor, zie of lees, haak ik af ok ? : )"

Because you asked: REBELLION! :) It's a lovely thing, isn't it?! But, it's hard to find in youth cultures nowadays. New generations seem to have accepted the presence of brands (and commerce in general) in almost every aspect of life. They still have their opinions, but when it comes to opportunity or business they don't seem to act on them.

Is opportunism the new rebellion?

What's in a name?  Opportunism is a way to reach a goal with a different standard, to adjust your view because it's more convenient. Rebellion is enforcing your own standard onto others, or to hold on to them. To resist authority, in whatever way. It's not the one as the other, it's more a complex cause and effect of different aspects. If something gets too familiar, there will be counteraction. Marketeers know this, but they also know it's not that rebellious to swipe your credit card. So they incorporate all sorts of means to trigger this rebellious feeling. The Fightclub-feeling, that 'you are one of us' when wearing this or that.

Street artists are the perfect 'cannonfeed' to proudly fulfil this task. To help the poor non-identity brand with some creative pimping. It's advertising. It's Adidas, It's Opel. Shoes. How rebellious is wearing shoes or driving a German shopping-car?

This reminds me of using breakdancers in videoclips some time ago. No matter the music, breakdancers HAD to be used. It gets completely taken out of context to get a flimsy street-vibe in return. Hilarious.

If rebellion means wearing a Ché Guevara-shirt I guess the battle is lost beforehand. As a kid I remember being very impressed by Public Enemy's "Don't believe the hype". "Do believe the hype" seems more appropriate nowadays. 'Rebellion' becomes conformity within a couple of years, or months even.

- How do you think subcultures should deal with 'hype'? We all know not to believe the hype cause its usually the hype that transforms the original thing into a sugarcoated travesty. But a hype is something that happens, whether you want it or not. The time of just being against it or trying to stop it is over, 'cause history shows us that it's just not realistic and it means you're biting yourself in the ass. AND it means you're letting your culture go and you have to go and start or find/create something else 'till it all happens again.

So, how to get the best out a hype, stay hands on, profit from it in various ways and still 'keep it real'?!

This sounds very external. If you see it like this, sure, you're in it and there seems no way out. If hype is fashion or it's fashionable to stay in front of the hype, it's an ongoing rat race. You decide.

Subcultures always seem to originate at a certain place at a certain time out of some basic need, a need to

find like-minded people and discover the sky's the limit, within your own codes. Whether it's dubstep or bicycle messengering, rockabilly or skateboarding. Hiphop started with people that had no instruments using basic materials (2 turntables and a microphone) to get busy. Graffiti used carpaint spraycans to give a voice to the ghetto. Whatever.

I doubt whether commercialism plays a big part in this in the beginning. Perhaps after a hype is created, a movement has evolved the brands jump in the field like grasshoppers. It makes sense for a brand to wait some time for a movement to grow big and than jump in and do the cashing. On the other hand I guess also these subcultures can dry up if not adjusted and refreshed, or simply because times change.
I sometimes see it like this with hiphop for instance; the decadence of blingbling gangbanging bitch-ass big car nobrain hiphop seems to almost refer to the times of decadent Roman emperors announcing the end of an era. We'll see. It's an ongoing play of cause and effect. It's interesting.

- It's certainly interesting, and I agree that things always will, and have to, evolve.
But what I mean with 'staying hands on and profiting from a hype' is not: "how do we make sure we drag as much (cash) out of it", but more in order of protecting ourselves and what we like or do. In the past and often still, some people create something amazing, just like what you're talking about, on their own terms, with

their own means, coming from a certain need.
And then it gets jacked off them, thrown in a
shiny jacked and the originators and their
culture are left with nothing.

I'm not saying: "okay, lets do that process
ourselves and get paid for it at least". But I also
believe that just saying that it sucks, be against
it and watch it happen isn't the answer.

Punk is a movement that had music, fashion,
graphics, skateboarding, politics, graffiti, all on
lock down at one point. As soon as things
transform or reach a bigger audience they leave
it. The people who call themselves punk now,
have dogs, amphetamine and beer. I think that's
simply a shame.
If you see it as a battle, they lost. I'd like them
to win.
P.S. I still believe the punk attitude is out there,
just not in so much in punk, just like sex used to
be a lot more sexy ;)

I know I'm being pretty bold on statements here,
but lets say, 'for arguments sake'...

Of course as an individual, you can just keep
doing what you love to do, and maybe that is a
big part of 'the answer'. But more collectively,
what should creative youth culture be thinking

about right now, with all the corporations on their young, sweet, marketable asses?

That's a lot in one question, but to start with the 'what to do?' -part; I think a very healthy approach on a personal level is to try to keep on progressing, to doubt, to question; so much graffiti, punkbands, hiphopsongs etc. etc. are more about acknowledging subcultural clichés instead of avoiding them, questioning them, not caring about them or to bend them differently.

If there is a 'big grey middle' in all these different subcultures it will be easy to pinpoint externally, and therefore easy to commercially exploit.
The breakdancer in the Madonna or Mariah fucking Carey-clip for instance, or the street art-extravaganza car-advertisement. Of course this happens; it makes complete sense.
If a subculture gets so easily pinpointable it's a piece of cake to copy or exploit for moron-marketeers.
The good thing about it is it mostly gets done in a rather clumsy, obvious way.

Here the 'new' situation we talked about before kicks in; the creative industry that blends more and more into the subcultures; it's clever. Trojan-horse style. It's a way to avoid the subcultural clichés, but get more and more into the core of the field. And to get this core in touch with clients that would never be able to reach these people. I guess this is the 'best' way to leach from a subculture. To hijack the 'originators' like you say,

so every form of criticism is blocked out, and every customer in need can keep it real wearing the latest limited editions... without having to do anything for it, except being an obedient customer.

Remarkable is that it's not so much the companies but the people from subcultures that are more than eager to 'sell out' Here comes the collective part probably; 'creative youth culture' should probably be thinking; this is not what we want it to be. But to realize that, they should see it themselves. Individually.
So probably it all gets down to individual opinions that choose not to go along, or decide different. 'Een beter milieu begint bij jezelf-style' haha.

We live in the 'free, civilised western world'; why than is it that for some reason we get more and more things to choose from every day, but in the big picture the choices get more and more limited... the 'Pepsi or Coca-Cola'-effect. Or Nike or Adidas. Apple or Microsoft ( isn't that the same by now?). It's almost like capitalism gone retarded; drifting off to communist times of government-controlled choice. The same for everybody. Everybody the same.

Of course big brands don't want to be pinned down like that, so the 'limited edition' is invented. Some invention! Best thing to do I guess is to try and support a more small-scaled effort. Small brands or initiatives doing great things.
It's like restaurants; best food you can get in the most obscure places that mostly don't look fancy at all.

So in that sense; punk to my idea has nothing to do with leather jackets, buttons and stretch-jeans. That's the cosmetic side of it all. That whole Sex Pistols-vibe has become such a (marketed) cliché in itself. Maybe not caring about a collective view is more punk than punk can be. We live in a free world (still kind of), and we still have a choice. Even a choice to not choose. That's luxury. What to do with it? You decide.

- Commercialism and creative culture are walking hand in hand more and more and the relationship seems to be improving, brands and big companies sometimes offer a lot of creative freedom to young creatives and pay better than before.
The attitude of the cultural world towards this phenomena is also getting more open. On the other hand there are still plenty of examples that show us we should remain critical and maybe even sceptical.
In your eyes, what would be the ideal relationship between culture and commerce? Where do you see things going and where would you like to see them go?

I don't know. This is too splintered and complicated to easily answer. There is a place for culture and a place for commerce I guess. What we talk about here seems to be the way things are going; an evermore intertwining between the two, making it less obvious what is what.

I just hope to not see brands get their noses in every aspect of life. That not everything brands do gets labelled 'cool' with no aspect of criticism involved. I guess it gets strange when things become too camouflaged, when things get too mixed up... I am quite curious to see if consumers will get more critical as this progresses.

For instance 'limited edition Nike shoes' is simply a contradiction. Nothing wrong with wearing nice shoes, but apart from this I can't get away from the idea that Nike also equals sweatshops for instance, just like most big brands equal sweatshops. Do we care? Will this change? Only if a majority of the consumers wants to. Same thing for branded cultural events. If it's beneficial for the quality, experiment, freedom why not? But of course... what's beneficial or what is quality and who decides? If brands dare to not only figure out a way to upgrade their digits as the only objective there could be possibilities I guess. I doubt how and if that will happen. It will still be advertisement if you want it or not.

- It's an interesting subject to me because it's happening. It's happening right now and people are experimenting with it.

If I see or hear about corporations showing 'responsibility' and 'respect', on one hand I think that's great, but on the other hand I think it's scary to almost believe that a legal entity

like a corporation is actually capable of having a 'human' side like that. You know what I mean?

Err...it doesn't matter if they have this side or not... it's more how and what they will use to make you believe they have it and if this works or not.

It's all rabbit-in-the-hat-tricks. It's illusionism. You believe it if you want to believe it. Again; the interesting part to me seems to be a more small-scaled approach of people starting things grass-root. There are so many possibilities through the internet for instance, it's getting more and more easy to get a 100% limited edition sweatshop-free sweetlooking T-shirt from the other side of the planet... instead of just another camouflaged swoosh on your chest. Just by searching for the good stuff and clicking buttons. Maybe you pay a bit extra, but if it's more direct support to people responsible for it, it's perfect. Who needs big brands for this? It would be nice to see this as a development in the near future instead of big brands getting bigger, and more aggressive in trying to capture the full spectrum using 'young urban professionals'.

They know that it's a losing battle towards people getting more and more independent and splintered as a target-group, so anything they try will be in favour of tricking people into buying their stuff...

I don't know if thinking about and/or reacting to this is called opportunism or rebellion, but it seems the only interesting and realistic option.

Erosie

What would be your advice for kids in the creative field, and to the world...

Haha... don't believe the hype?

# COLOPHON:

**Text(s):**
All the texts have been brought
about through conversations
and e-mail interviews

**Editing:**
Tobias Krasenberg

**Translation:**
Influenza's text was translated
by Henk J. Krasenberg

**Design:**
Tobias Krasenberg

**Printing:**
Veenman Drukkers

**Publisher:**
Veenman Publishers/ Gijs Stork
Sevillaweg 140
3047 AL Rotterdam- NL
t. +31 10 245 3333
f. +31 10 245 3344
info@veenmanpublishers.com
www.veenmanpublishers.com

ISBN 90-8690-099-2

**Distribution:**
D.A.P.
155, Sixth Avenue, 2nd floor
New York, NY 10013, USA
t. + 1 212 627 1999
dap@dapinc.com

Idea Books
Nieuwe Herengracht 11
1011 RK Amsterdam-NL
t. +31 20 622 6154
idea@ideabooks.nl

Art Data
12, Bell Industrial Estate
50 Cunnington Street
W4 5HB London- UK
t. +44 20 8747 1061
info@artdata.co.uk

**Very special thanks to:**
All the people in the book:
Mike Clark,
Karl Grandin,
Marco Sterk,
Mo and Jessica at Best Company,
Influenza,
Pepijn Lanen and
Erosie!

Linda van Deursen,
for making this happen and for all
her great support and guidance.

Marieke Stolk at
Experimental Jetset,
for support and guidance.

Will Holder

Letty van der Geest, Ton Verlind,
Julia Krasenberg and
Henk J. Krasenberg.

Samuel de Goede, and other friends,
for all the long talks and
discussions about this topic.

..........................................

Nowadays, if we speak about
graphic design we can never
be sure if we are actually talking
about the same thing.
The books in this series investigate
different fields of graphic design
where this lack of definition
currently exists, as a means to
contribute to the discussion and
awareness of an arbitrary
profession.

Hard School Books.
Graphic Design Department,
Gerrit Rietveld Academie,
Amsterdam, June 2007